IMAGES
of America
GREENSBURG

C. J. Corbin, a Philadelphia publisher of historic panoramic maps, added Greensburg in 1879 to its well-distributed series featuring cities and towns. The buildings highlighted in the book include Kepple's Carriage Works, Zion's Lutheran Church, the Presbyterian church, the J. A. Marchand residence, the Lomison Opera House, and the C. A. Stark residence. (Courtesy of the Booher Family Archives.)

IMAGES of America
GREENSBURG

P. Louis DeRose

ARCADIA

Copyright © 2004 by P. Louis DeRose
ISBN 0-7385-3652-0

First published 2004

Published by Arcadia Publishing,
Charleston SC, Chicago IL, Portsmouth NH, San Francisco CA

Printed in Great Britain

Library of Congress Catalog Card Number: 2004107288

For all general information, contact Arcadia Publishing:
Telephone 843-853-2070
Fax 843-853-0044
E-mail sales@arcadiapublishing.com
For customer service and orders:
Toll-free 1-888-313-2665

Visit us on the Internet at www.arcadiapublishing.com

In the midst of the Depression, Greensburg somehow continued its two decades of sustained growth, surpassed only later by the postwar boom. Here, North Main Street is seen during the 1930s, the very picture of a successful small city. (Courtesy of the Cy Hosmer Collection.)

Contents

Acknowledgments 6

Introduction 7

1. Rounding the Corner in Style 9

2. Common Threads 35

3. Fading Glory 101

Acknowledgments

No single author can be responsible alone for a work like this. I am grateful for the willing and generous participation of friends Ned and Hazel Booher, Wib and Margie Albright, and Glenn Smeltzer. Glenn graciously gave me access to his father's collection of photographs. Also providing photographs were Cy Hosmer, a fellow postcard collector, as well as Jim Silvis, Vance and Vicki Booher, Harvey Waugaman, Bill Mohler, David Jamison, and John Pollins. Tom Headley, executive director of Westmoreland Heritage, provided the initial impetus and encouragement to get me started. I am indebted to Robert B. Van Atta and Jim Miller, both of whom wrote splendid books on Greensburg history in great detail. Special thanks go to the Westmoreland County Historical Society, the owner of many of the old photographs used in this book. Jim Steeley, executive director of the historical society, was particularly helpful in clearing the use of the photographs. Archivist Ed Hahn was always helpful and accommodating. A special thank-you goes to Jennifer Wilson of the historical society for her invaluable and patient assistance with this project.

At home, Joan, Peter, and Caty gave me their support and assistance over the weeks of assembling and proofing the material. At the office, Peter Cherellia, Mike Rubinoff, Judith Hudson, and Rita Turco were always encouraging and accommodating. Finally, I am deeply indebted to my assistant, Judy Brodmerkel, for her very capable help and eternal good cheer.

Introduction

As the early colonists pushed westward, a series of forts was built up and over the mountains of western Pennsylvania. The road that connected these early forts was used not only by the military but also by new settlers seeking a fresh start in what was then the west. Migration slowed to a stall until the end of the French and Indian War. Once it was safe, travel was reestablished, and a steady stream of pilgrims pushed over the Alleghenies into the rolling countryside of western Pennsylvania, toward Pittsburgh. Midway between Fort Ligonier and Fort Pitt, a cluster of cabins was built to provide food, shelter, and supplies to those intrepid travelers. Some of these westbound pioneers decided to stay in this hamlet, then called Newtown.

Once the state chose Newtown as the seat of government for all the western territory east of Pittsburgh, the future success of this community was assured. Renamed for Revolutionary War hero Gen. Nathanael Greene shortly after his death, Greensburg continued to grow and prosper but at a very slow rate. It was the first county seat of government and home to the first state courts west of the Alleghenies. In 1799, the community leaders established a borough form of government. For the first time, there was a recognized entity known as Greensburg.

After the Civil War, with the main line of the Pennsylvania Railroad running through its center and with rich farmland and bituminous coal mines surrounding it, Greensburg emerged as the commercial and industrial center of the region. As the community turned the corner into the 20th century, it displayed its newfound prosperity with beautiful, large homes and impressive new commercial structures.

Through two world wars and the Great Depression, Greensburg remarkably continued its steady growth until the early 1960s. The decline that followed would last 20 years and is, in some ways, still unresolved.

Located in the geographic center of Westmoreland County, approximately 30 miles southeast of Pittsburgh, today Greensburg is home to many local, state, and federal agencies serving an area population of over 75,000 people. The historic Lincoln Highway, the Pennsylvania Turnpike, the Arnold Palmer Regional Airport, Amtrak, and Norfolk Southern all service its transportation requirements. The community is also served by Seton Hill University and the University of Pittsburgh at Greensburg, as well as nearby St. Vincent College and Westmoreland County Community College. Flanked by urban sprawl to the west and by bucolic farmland and recreation areas to the east, Greensburg is the cultural center of the county. It is home to the Westmoreland Museum of American Art and the Palace Theatre. Along with the colleges and universities, these institutions are regular hosts to enriching art

and entertainment opportunities. Nearby historical sites include the Hannastown settlement and Bushy Run battlefield, which celebrated the 250th anniversary of the French and Indian War in 2004.

With its neighbors Hempfield Township, South Greensburg Borough, Southwest Greensburg Borough, Salem Township, and Unity Township, Greensburg is the center of a growing and ever changing portion of Westmoreland County. Time and history have indeed brought changes to the face of the city and altered its destiny, but it remains, as it always has been, a fine place to live and work.

One
ROUNDING THE CORNER IN STYLE

After the Civil War and before World War I, Greensburg began a period of slow yet sustained growth and development. The completion of the Pennsylvania Railroad to Pittsburgh helped fuel this growth, as did the development of bituminous coal mining near the end of the 19th century. Already well established as a seat of government, Greensburg was called home by more and more workers from Europe, as well as men and women from the East Coast. These new residents built schools, churches, and stores. They needed banks, hospitals, and more roads. Farmers found buyers for their products, and manufacturers found able-bodied men to work and a network of rail lines to deliver their goods to other markets. By end of the 1800s, a wealthy class was born, and the population of the area swelled. The demand for more services spawned new and better jobs. With a burgeoning population working and earning more money came the need for entertainment and transportation. Greensburgers responded to these challenges and, by 1900, were on their way to a second 100 years of growth and success that would, for a time, establish Greensburg as the finest town between the Allegheny Mountains and Pittsburgh.

In 1848, Greensburg's volunteer firefighters acquired their first pumper, the *Pat Lyon*, from Pittsburgh. It served the area alone until the Good Will fire engine was purchased (also from Pittsburgh) 10 years later. Both engines were hand drawn and hand pumped. By century's end, these two could not handle the load that a growing community put on them. (Courtesy of Edward H. Hahn, Archives, Westmoreland County Historical Society.)

Remodeled and improved in 1893, the first Pennsylvania Railroad station in Greensburg stood until 1909. A tunnel under Main Street was used by the railroad until the tracks were raised in 1910. This eliminated the grade crossing at Harrison Avenue, and the old station gave way to a new one in 1911. The 1911 station was restored by the Westmoreland Trust in 1997. (Courtesy of Edward H. Hahn, Archives, Westmoreland County Historical Society.)

One of several military-style bands was the Citizens Cornet Band, pictured here in 1883. These groups were very popular from the years after the Civil War into the early 1900s. After the century mark, nationally known groups began to appear in Greensburg, causing the popularity of local bands to wane. Many talented early musicians got their start, however, in these organizations. (Courtesy of Edward H. Hahn, Archives, Westmoreland County Historical Society.)

This 1899 photograph shows Westmoreland County's third courthouse displaying its flags and banners proudly for the Fourth of July. The structure, built in 1856, housed the courts and county offices for 50 years. By 1900, however, more space was needed. The building was demolished in 1901 to make way for the beautiful fourth courthouse, still serving the county today. (Courtesy of Edward H. Hahn, Archives, Westmoreland County Historical Society.)

Near the turn of the century, James Henry joined an existing hauling business, owned by Frank Peifly, to form Peifly and Henry Freight & Delivery. Housed near the Pennsylvania Railroad freight station in Ludwick, the hauling concern on Stokes Street was not James Henry's only business. He also owned Henry and Sheffler's Garage and Machine Shop nearby. (Courtesy of Edward H. Hahn, Archives, Westmoreland County Historical Society.)

Greensburg Seminary, associated with the Lutheran synod, opened in 1875 with a four-year curriculum. Around 1900, there was an abortive attempt to locate Thiel College on this site. Failing that, the seminary closed in 1904. The hilltop property was purchased in 1905 by Thomas Lynch, who built his magnificent home there. The Lynch home still stands at Seminary Avenue and West Pittsburgh Street. (Courtesy of Edward H. Hahn, Archives, Westmoreland County Historical Society.)

This early view of Seton Hill from the railroad right-of-way near the station shows the Stokes-Jennings Mansion, as well as the barn and other outbuildings, along with the newly built St. Joseph Academy. Of interest is the boardwalk running from the hill down to the railroad station, through the area that was once known as Mudville. (Courtesy of the Booher Family Archives.)

This second schoolhouse in Greensburg was known as the District School. Built in 1852, it was located on the east side of South Main Street. About 10 years after opening upon completion of the new schoolhouse, "Old Red," atop Academy Hill, in 1863, the District School was sold to become a private home. (Courtesy of Edward H. Hahn, Archives, Westmoreland County Historical Society.)

The borough of Southeast Greensburg merged into the city of Greensburg in 1905, and along with Southeast Greensburg came Paradise School, its name reflecting the pre-1893 name of that area. Hose Company No. 8 is still known today as Paradise Hose Company. After its days as an elementary school, the Paradise School building was the Bowman residence. Local historian Wib Albright's father, Harry, is in the second row, fourth from the left. (Courtesy of Edward H. Hahn, Archives, Westmoreland County Historical Society.)

One mark of a prosperous community is the quality of the churches built. Early on, Greensburg hit the mark grandly. At the southwest corner of Third and Main Streets stood the second building housing the First Presbyterian Church at this site. This structure was built in 1884 by a congregation formed originally in 1788. One of the pioneer churches in Greensburg, it was demolished in 1916 and replaced by the large stone edifice there today.

This First Lutheran Church stood on the northwest corner of West Third and South Main Streets. Known as the Beehive Church, it was constructed in 1815 and was demolished in 1883 for a new edifice, which opened in 1885. The Beehive Church was a landmark structure on Main Street. The busy, popular church contained the first church organ in town. (Courtesy of Edward H. Hahn, Archives, Westmoreland County Historical Society.)

Holy Sacrament Catholic Church stood on Academy Hill from 1848 until its replacement was built in 1925. This was the third Catholic church erected in Greensburg since the founding of a Catholic parish in 1789. By 1900, a much larger church was needed to meet the needs of a growing immigrant population, but it was not until 1925 that the present cathedral was built. (Courtesy of Edward H. Hahn, Archives, Westmoreland County Historical Society.)

The Merchant's Hotel, at West Otterman Street and Harrison Avenue, was owned by the Stark family, who would eventually own the entire block fronting West Otterman Street. Constructed in 1888, this was one of several hotels owing its existence to the proximity of the Pennsylvania Railroad station. After falling into disrepair, the structures were adapted and renovated by the Westmoreland Trust in 2004. (Courtesy of Edward H. Hahn, Archives, Westmoreland County Historical Society.)

The Keaggy Building stood on the east side of North Pennsylvania Avenue until the large expansion of the corner property into what was once the Manos and is today the Palace Theatre. J. B. Keaggy and his wife inherited the building from Dr. H. G. Lomison in 1894. (Courtesy of Edward H. Hahn, Archives, Westmoreland County Historical Society.)

Lewis Trauger Dry Goods, at 128 North Main Street, was the area's largest store of its kind in the 19th century. Lewis Trauger came to Greensburg in 1842. When he died, his store was operated by Wil Welty and was later known as the New York Store. Trauger was also president of the Merchants and Farmers National Bank. (Courtesy of Edward H. Hahn, Archives, Westmoreland County Historical Society.)

Zahnizer Lumber, pictured here c. 1892, was located at the Depot Street rail yard in Ludwick from c. 1887 until 1902. There was also a planing mill downtown on West Otterman Street, across from the Shoemaker & Company Mill. (Courtesy of Edward H. Hahn, Archives, Westmoreland County Historical Society.)

Since they were dependent on the railroad for supplies, many businesses located right along the rail lines. D. F. Kilgore & Company and others received shipments via the railroad and by horse-drawn wagons until the truck pushed the horse off the streets. Larger trucks meant that locations along the railroad were no longer necessary, resulting in businesses spreading throughout the area instead of just along the tracks. (Courtesy of the Cy Hosmer Collection.)

At the turn of the century, the Beck Brothers store stood on the southwest corner of Spring and Otterman Streets. Beck's sold an eclectic assortment of goods for people and horses. A few years later, Butch Waugaman founded Waugaman's Market. Eventually located next door to Beck's, the market—and two generations of the Waugaman family—served the needs of families in the vicinity until 1995. (Courtesy of Edward H. Hahn, Archives, Westmoreland County Historical Society.)

This photograph was taken from immediately behind the Beck store, looking up Spring Street. At that time, only a few houses had been built. Spring Street was unpaved, but that was not unusual for most streets until well into the 20th century. (Courtesy of Edward H. Hahn, Archives, Westmoreland County Historical Society.)

The Westmoreland Hospital Association was founded in 1895 by Dr. R. B. Hammer, Dr. Frank Cowan, and other like-minded persons to serve the town's medical needs. The hospital was opened in 1896 in two homes on West Pittsburgh Street—the in-town home of Dr. Cowan and the adjoining property, pictured here. This structure, now razed, was later the law offices of Meffe & Ober. (Courtesy of Edward H. Hahn, Archives, Westmoreland County Historical Society.)

The Spanish-American War (1898) saw a number of local citizens participating. Here National Guard Company I marches to the train station for a send-off by a large number of Greensburgers gathered there. This company would undergo further training at Mount Gretna and then leave for Manila and active duty in the Philippines. (Courtesy of Edward H. Hahn, Archives, Westmoreland County Historical Society.)

May 25, 1899, brought the largest celebration in the town's history. It had been 100 years since the incorporation of Greensburg as a borough on February 9, 1799. Enormous crowds (up to 40,000 people) came to town that day for the festivities. There were speeches, fireworks, and a parade that was over one mile in length and several hours long. (Courtesy of Edward H. Hahn, Archives, Westmoreland County Historical Society.)

This log house, built in 1751, was typical of homes early in the 19th century. This Baum farm residence, two miles west of Greensburg, stood until after World War I, when it burned. After the Civil War, with a settled prosperity taking hold, new and finer homes began to appear. By 1900, many fine mansion-size structures lined the main streets. (Courtesy of Edward H. Hahn, Archives, Westmoreland County Historical Society.)

On East Pittsburgh Street, near the eastern city limits, is the home of John M. Jamison, president of Jamison Coal and a state senator in the first decade of the 20th century. The Greensburg Catholic Diocese is now headquartered there, having added newer wings to the building more recently.

After the demise of the Greensburg Seminary, wealthy industrialist Thomas Lynch, president of H. C. Frick Coal & Coke Company and other mining interests, acquired the property to build perhaps the most outstanding of the West Pittsburgh Street mansions. Both this structure and his adjoining original home are in use today. The newer home at 414 West Pittsburgh Street was acquired by the Old Republic Insurance Company, which currently has offices there.

The current YWCA, located at 424 North Main Street, was originally the William A. Huff home. It was later the home of John M. Horn. Built c. 1900 in neoclassical style, it has been enlarged, restored, and repainted by the YWCA. Over 100 years after its construction, it is one of Main Street's most attractive and impressive homes.

This lovely Victorian home is located at 426 West Otterman Street, at the intersection with Gaither Way. Recently refurbished to close to its original look, it is typical of the fine homes of this architectural type built throughout the town between 1890 and 1920. (Courtesy of Edward H. Hahn, Archives, Westmoreland County Historical Society.)

Although it now has new siding and a more traditional porch, this Victorian home at Seminary Avenue and Rohrer Street still features the stone-wall front and side. During the boom years at the turn of the century, dozens of these same style homes were built, in addition to the 20 or so stately mansions. (Courtesy of Edward H. Hahn, Archives, Westmoreland County Historical Society.)

Jacob Whitehead owned and operated the Valhalla Roller Mills at Radabaugh, located along the Pennsylvania Railroad tracks, directly behind the now demolished Greengate Mall. It produced, among other products, Valhalla, a popular local flour. Whitehead used the Valhalla name to capitalize on Dr. Cowan's well-known estate nearby, Mount Odin, which Cowan often referred to as Valhalla. (Courtesy of the LeRoy Smeltzer Collection.)

Around 1902, at the corner of Depot and Ludwick Streets, across from the still standing Pennsylvania Railroad freight station, the Greensburg Storage & Transfer Company built its enormous facility. It was so large that a train could drive right into it—and did. Freight yards, lumberyards, grain warehouses, grocery warehouses, and sheet metal works were across Depot Street. Some of the rail yard tracks are still evident today. (Courtesy of Edward H. Hahn, Archives, Westmoreland County Historical Society.)

In 1890, the first trolley line was begun by local investors, including the Jamisons and Huffs. Named the Greensburg and Hempfield Electric Street Railway, it ran five miles around town, originating at the railroad station. It is seen here on North Pennsylvania Avenue. Twenty-five years later, various competing lines were consolidated into the West Penn Railways Company, the forerunner of the West Penn Power Company. (Courtesy of Edward H. Hahn, Archives, Westmoreland County Historical Society.)

Car No. 1 of the Greensburg-Hempfield line is seen here rounding the corner of West Pittsburgh and North Main Streets in the summer of 1899. The old courthouse still graced this corner. Shortly after, the Greensburg-Hempfield line sold to the Westmoreland Railway Company, with trackage to Oakford Park and Jeannette. Two years later, the courthouse was demolished. No grass lawn or iron fence would surround the new courthouse. (Courtesy of the Cy Hosmer Collection.)

Originally called the Lomison Opera House and owned by Dr. H. G. Lomison and his wife, Anna McCausland, this theater was later called the Keaggy Theatre and, later still, the Strand. Used not only as an opera house, it was also a sports arena, vaudeville stage, movie house, and gymnasium. It was eventually torn down and replaced by a courtyard used by the Palace Theatre. (Courtesy of Edward H. Hahn, Archives, Westmoreland County Historical Society.)

Changes were a few years away at the time of this view of Pennsylvania Avenue and Otterman Street. On the left, we see Mrs. C. H. Stark's home before renovations transformed it into the Rialto Cafe. To the right is the home of Anna McCausland. Major reworking of the structure and facade later created businesses, including the Tavern Hotel, the Rialto Theater, and later, in the 1920s, the Manos. Today it is the Palace Theatre. (Courtesy of the Cy Hosmer Collection.)

The 1900s brought many small businesses, such as the Smeltzer Brothers Cabinet and Repair Shop (in the Fifth Ward), which took hold and prospered. Located in what is now a private home on Cherry Street up from Anderson's Market, the shop was operated by three brothers, Henry Clemens Smeltzer, Harvey Smeltzer, and Logan Smeltzer, until the Great Depression. (Courtesy of the LeRoy Smeltzer Collection.)

The last, and perhaps best, of the early local military bands was the Greensburg City Band, organized in 1892 and pictured here in 1896. This group regularly performed at the bandstand on Pennsylvania Avenue, prior to the erection of the Rappé Hotel. The group traveled to adjoining states and other nearby communities to perform and also kept a local concert schedule. (Courtesy of Edward H. Hahn, Archives, Westmoreland County Historical Society.)

Once the decision was made to replace the existing courthouse in 1901, construction began in earnest on the current building, which was completed in 1908. It did not take that long to build; construction was slowed by infighting between the judges and county commissioners. Local and immigrant stonemasons joined together to cut the stone on site. This postcard shows the pile of debris from this cutting operation.

When Buffalo Bill's Wild West Show came to town, complete with cowboys, Indians, stagecoaches, sharpshooters, and stunt riders, a parade through the community was essential in order to let everyone know the show had arrived. Here, part of that parade is pictured turning the corner from West Third Street onto South Pennsylvania Avenue in front of the post office. Buffalo Bill drew large crowds everywhere he visited, including Greensburg. (Courtesy of Wib Albright.)

There are several families of lawyers whose surnames were prominent in 1900 and are still prominent today. One such family is depicted here in 1900 in the office they shared at the Bank and Trust Building. Seated is Zachary Taylor Silvis (1867–1951), and standing is his brother, Jacob Rence Silvis (1862–1941). Richard Silvis (1904–1991), who practiced law in the middle of the century, was Z. T. Silvis's son. James R. Silvis is the great-grandson of J. R. Silvis. He maintains offices today with his son, James P. Silvis, at O'Connell & Silvis on West Pittsburgh Street. (Courtesy of James R. Silvis.)

In this *c.* 1900 photograph, taken from the courthouse looking north toward Academy Hill, we see the old Null House in the center, on the corner of West Otterman and North Main Streets. This photograph was taken prior to the removal of the Pennsylvania Railroad tunnel. Also visible here are Holy Sacrament Church, at the top, and Trinity Church, on the right. (Courtesy of the Cy Hosmer Collection.)

On an 1888 outing to Kissel's Spring near Waterford, newly arrived owners John T. Kelly and George M. Jones pose with their plant superintendent, L. D. Castle, and two well-known political figures, James C. Clarke (a judge) and attorney William Peoples (later to be district attorney). Kelly and Jones sold their valve and fitting plant to the Walworth Company in 1925. (Courtesy of James R. Silvis.)

Around 1900, several small mines were started in and around Greensburg. This photograph shows Keystone Coal Company's Seaboard Shaft. It was located where C. A. Walter Moving is today, at 740 Stanton Street. Expanded and altered, at least two of the old buildings are in use by the moving company. Prior to that, the property housed Leonard Brothers Trucking and a bus garage. (Courtesy of the LeRoy Smeltzer Collection.)

The Greensburg Coal Company, owner of the Radabaugh Mine, opened a second mine, the Hawksworth Mine, in 1913. Located below Seton Hill along the Pennsylvania Railroad tracks, its remains are visible today from Mount Thor Road near the railroad overpass. The section of town known as Gayville, for developer Freeman Gay, was built as company housing for the miners. (Courtesy of Edward H. Hahn, Archives, Westmoreland County Historical Society.)

One of the most attractive hotels in the city, the New Ehalt Hotel on Harrison Avenue, which was built before the Civil War, has been known by a number of names during its lifetime, including the Lincoln Hotel, the Union Hotel, and the Penn-Albert Annex. Like its brother the Penn-Albert Hotel, it was owned by the J. A. Sheets family throughout much of its existence. It started as a stagecoach stop and in its heyday was a sought-after accommodation for the large numbers of travelers passing through the Pennsylvania Railroad station nearby. For a time, there was a small filling station next door. (Courtesy of the Cy Hosmer Collection.)

Torn down in the early 1990s, West Penn Power's substation first saw use as a home for the transformers and generators needed to make and supply the power to operate the fleet of trolleys owned and operated by West Penn Railways. Today there is an outdoor substation located near here along Mount Pleasant Street. (Courtesy of Edward H. Hahn, Archives, Westmoreland County Historical Society.)

Before World War I, Greensburg was enjoying the greatest period of prosperity so far in its history. For the first time, the town took on the appearance of a bustling small city. The citizens pictured here certainly add to that impression. Greensburg had successfully entered the 20th century in style. (Courtesy of the Cy Hosmer Collection.)

Two
COMMON THREADS

To succeed over the generations, a community must build upon its stability and social traditions. These are created and fostered mainly by churches, the state, and industry. Greensburg is rich in these social traditions. The churches, fire departments, schools, railroads, and highways all add to that stability in different ways. By World War II, the community was in a period of prosperity that reflected a much brighter image than that of the rest of the nation. Perhaps it was because the area dealt in the fundamentals of transportation, coal mining, farming, and government that the Great Depression seemed to be less severe here than in other parts of the country. Perhaps, however, it was also because the events, places, and institutions in Greensburg reflected the personality of a people with good roots and strong traditions.

These, then, are the scenes of what bound Greensburgers together through boom and bust, on the roller coaster called the 20th century.

Mountain View Inn was built in 1924 along the Lincoln Highway five miles east of Greensburg. The hotel struggled through the Depression until it was bought by the Booher family in 1940. It remains in the family, operated by Vance and Vicki Booher. Today Mountain View is part of the Historic Hotels of America and is this area's premier inn. (Courtesy of the Booher Family Archives.)

Married in 1885, Edward H. Bair built this spacious home at 411 North Main Street for his new bride. Bair was an important real estate and insurance man, as well as an investor and civic leader. He developed the Underwood section of town. His grandsons, Edward B. (Ned) Booher and Vance E. Booher Jr., owned and operated Mountain View Inn, east of town, beginning in 1940. (Courtesy of the Booher Family Archives.)

Prior to building at 534 West Otterman Street in 1927, Butch Waugaman operated the West End Market across the street. Seen here in 1918 are Kenneth G. Waugaman (left) and his brother Clarence (Butch) Waugaman inside that butcher shop. Waugaman's grew and prospered in Ludwick for nearly a century, closing in 1995. (Courtesy of Harvey Waugaman.)

37

In 1920, the Manos family purchased these properties and began a series of renovations that would transform the block. The Rialto and Keaggy theaters are shown straddling Strand Sweets Shop, a very popular stop for the sweet tooth crowd. (Courtesy of the LeRoy Smeltzer Collection.)

In 1922, with the construction of the Penn-Albert Hotel, the intersection of Ehalt Street and Harrison Avenue had two homes remaining next to the New Ehalt Hotel. These were torn down three decades later, along with the Ehalt, to make a city parking lot. The lot and other buildings will be a part of the Seton Hill expansion in 2005. (Courtesy of Edward H. Hahn, Archives, Westmoreland County Historical Society.)

This very early view of the east side of North Main Street shows the structures in place prior to 1895. At left, the white structure is the Merchants and Farmers Bank. The Bank and Trust Building was constructed in 1896 on the southeast corner of Main and Otterman Streets, replacing the Homer Robinson Grocery. Also visible are Swen Wendel Shoes, John Murphey Jewelers, S. P. Brown Drugs, Adam Turney Hardware, and Lewis Trauger Dry Goods. These buildings all survived, with the exception of the Baughman Building, which was demolished in 1927. (Courtesy of the Booher Family Archives.)

This is a c. 1920 view of the northeast corner of Main and Pittsburgh Streets, showing the Baughman Building, which housed offices and Stephenson's Drug Store. Stephenson's was a fixture downtown from 1880 until 1927 and was reputed to be the first commercial store to have electricity. The building was demolished for the construction of the Barclay-Westmoreland Trust Company building in 1928, now an office of Citizens Bank, successor to Mellon Bank. (Courtesy of the LeRoy Smeltzer Collection.)

This photograph shows the east side of South Main Street, known as the "Old John Smith" corner, before 1900. We see Ehrenfeld Pharmacy, the Woolen Mills, Pollins Grand Depot Stores, the old First National Bank Building, and the Huff office building. (Courtesy of Edward H. Hahn, Archives, Westmoreland County Historical Society.)

This photograph was taken farther down Main Street at West Second Street; the Hotel Zimmerman is on the right, with the spire of the First Lutheran Church visible as well. Across Main Street are Dr. R. B. Hammer's home and office, as well as J. C. Penney and the LaRose Shop. (Courtesy of Edward H. Hahn, Archives, Westmoreland County Historical Society.)

This view from the intersection of West Second and South Main Streets shows the Hotel Zimmerman. The Zimmerman survived until 1921, when Prohibition sealed its fate. Troutman's Department Store would eventually replace it on this corner. In its day, the Zimmerman was a hub of activity and a plush dining and lodging spot in town. (Courtesy of Edward H. Hahn, Archives, Westmoreland County Historical Society.)

The Adam Fisher home on North Main Street at Tunnel Street is seen here after it was converted into a business property as well as a residence. The Coshey Livery can be seen directly behind this home. Adam Fisher was a well-known jeweler and maintained his shop in this storefront in his later years. (Courtesy of Edward H. Hahn, Archives, Westmoreland County Historical Society.)

The Null House, formerly the Westmoreland House, stood at the northwest corner of Main and Otterman Streets, prior to the Civil War. Owned by Harrison Null and then Levi Portzer, it was demolished in 1922 and replaced by the Union Trust Building. No longer a bank, it is now an office building and houses a dance school. (Courtesy of Edward H. Hahn, Archives, Westmoreland County Historical Society.)

This 1907 postcard shows mostly the west side of South Main Street, starting from left with the Masonic Building, up to the Fisher House and courthouse at Pittsburgh Street. Main Street at this time was paved with bricks and had trolley tracks.

Shortly after the construction of the new Pennsylvania Railroad station, this photograph was taken from West Otterman Street, looking north on Harrison Avenue. On the right is the Stark Building and the Monahan Hotel, formerly the Dixon Hotel. On the left is the home of Ada McCullough, widow of Congressman Welty McCullough, and the New Ehalt Hotel. Both are now parking lots. (Courtesy of the Cy Hosmer Collection.)

Here we see the c. 1921 demolition of a building housing Ehrenfeld Pharmacy at East Pittsburgh and Main Street, originally the Harbaugh Tavern. Three generations of Harbaughs ran this site, spanning the 19th century. It included horse stables in the rear, which the family used for coach lines between Pittsburgh and Philadelphia. The site was replaced with a more modern structure housing F. W. Woolworth and smaller businesses. (Courtesy of the LeRoy Smeltzer Collection.)

One of Greensburg's finest directs traffic in front of the Woolworth store, built in 1923. The store was later Thrift Drug until its acquisition and demolition by Southwest Bank. It is now a landscaped area owned by First Commonwealth. (Courtesy of the LeRoy Smeltzer Collection.)

Sears opened in 1932 and remained for 30 years at this location. Today, the building houses professional offices. The signs apparent on Main Street testify to a busy commercial district at the time. (Courtesy of Edward H. Hahn, Archives, Westmoreland County Historical Society.)

Compared to the late-1940s picture at the top of the page, this earlier view of Main Street clearly shows the changes that took place in the 30 years between the photographs. The corner structures on the right were replaced by larger commercial buildings. The buildings on the east side of the street, however, were still intact by the time the later picture was taken. (Courtesy of the Cy Hosmer Collection.)

Quite a crowd is gathered on South Pennsylvania Avenue on this day in 1920. The Westmoreland County Jail is visible on the right, as is the Cope Building. The other structures, which housed various establishments over the years, are long since demolished. (Courtesy of the LeRoy Smeltzer Collection.)

In this pre-1893 photograph, South Pennsylvania Avenue is shown from Zion's Lutheran Church northward. The streets and sidewalks were unpaved. Many of the structures between the church and the jail have not survived, including the jail itself. And indeed, the utility pole is in the street. (Courtesy of the Booher Family Archives.)

Formerly the Hacke home, this dwelling at West Third and South Main Streets served as part of the First Lutheran Church. It was demolished in 1959, when the church built a modern addition in that location. (Courtesy of Edward H. Hahn, Archives, Westmoreland County Historical Society.)

The Coulter Building at 231 South Main Street was built in 1903 and used as a temporary county courthouse while the current courthouse was under construction. Since that time, it has been a professional office building, with storefronts at street level. (Courtesy of Edward H. Hahn, Archives, Westmoreland County Historical Society.)

47

Formerly the home of Lewis Trauger, this East Pittsburgh Street home was purchased in 1901 by the Elks organization. The Elks lodge remained a fixture at this location until disbanding in the 1990s. It is now a private club. Visible to the left is the Baggy Knee restaurant. (Courtesy of the Cy Hosmer Collection.)

With the demolition of the Hotel Zimmerman in 1921, Troutman's constructed the area's largest department store on the site. The old Troutman's continued in operation across West Second Street until opening day. This photograph depicts the structural steelwork under way. Troutman's closed in 1985. (Courtesy of the LeRoy Smeltzer Collection.)

After the demolition of the corner structure and before the erection of the F. W. Woolworth building, residents had an uncommon view of the south side of the Baughman Building, which housed Lyons, Clements & Hill and other offices and businesses. (Courtesy of the LeRoy Smeltzer Collection.)

The trolley line ran south toward Youngwood alongside Walworth Company (Kelly and Jones). For 25 years, there was no road in this area. Automobiles at that time followed Broad Street past Railway and Industrial Engineering, south to Youngwood. In the late 1920s, Route 119 was carved out of the streetcar right-of-way. (Courtesy of the LeRoy Smeltzer Collection.)

Anna McCausland's old home went through a number of remodeling efforts. This c. 1920 view was taken when a new facade was placed on the Otterman Street frontage, creating a new entrance and larger building. (Courtesy of the LeRoy Smeltzer Collection.)

Once work was completed on the Rialto Theater frontage, the Manos family expanded the rear of the theater into what had been the Keaggy office building. This newly named Manos Theater had a seating capacity of over 2,100 when work was completed in 1926. (Courtesy of the LeRoy Smeltzer Collection.)

Before the official opening in December 1922, the newly completed Penn-Albert Hotel here stands tall over the surrounding area. Visible on left is the Coshey Livery and the newly completed Central Fire Station. On the right is the 12-year-old Pennsylvania Railroad station. (Courtesy of the LeRoy Smeltzer Collection.)

On West Pittsburgh Street, the Cope Hotel sits on the right, alongside a now demolished building, which housed the Colonial Bakery and offices. Beyond sits the Fisher House, fronting on Main Street. Out of sight to the left is the county jail. (Courtesy of the LeRoy Smeltzer Collection.)

The First Methodist Church stood on the northeast corner of Main and Second Streets from 1852 until it was demolished in 1907, when the church built a new edifice at East Second Street and Maple Avenue. (Courtesy of Edward H. Hahn, Archives, Westmoreland County Historical Society.)

This imposing stone church was built by the First Presbyterian congregation, starting in 1917. Designed in the English Gothic style, the church is one of the largest in the county and was the site of the 1991 memorial service honoring the 14th Quartermaster members who died in the Gulf War. (Courtesy of the Cy Hosmer Collection.)

Dedicated in September 1928, the Holy Sacrament Catholic Church is today the largest church in the county. It became Blessed Sacrament Cathedral in 1952, when the Greensburg Diocese of the Roman Catholic Church was created. (Courtesy of the Cy Hosmer Collection.)

After a fire, the First Methodist Episcopal Church was rebuilt in 1933 at South Maple and East Second Streets. The name was changed in 1945 to its present name, First Methodist Church. (Courtesy of the Cy Hosmer Collection.)

The Westminster Presbyterian Church was constructed in 1892 and served the congregation until a new church was built on Route 819 in 1995. The church building shown here serves a new congregation now; it was acquired by the Laurel Highlands Church of God, whose members occupy it today. (Courtesy of the Cy Hosmer Collection.)

In 1945, two congregations joined together to form the Otterbein Evangelical United Bretheran Church, located at College Avenue and West Otterman Street, now known as the Otterbein United Methodist Church. Completed in 1908, this building was the second building used by these congregations. (Courtesy of the Cy Hosmer Collection.)

The Church of the Brethren built a small church in 1910 at Mace and Stanton Streets. In 1912, the congregation built this larger building at the same site. In 1966, the third and existing church building was erected to serve the members. (Courtesy of the LeRoy Smeltzer Collection.)

St. Joseph's Academy, begun in 1886, was the first building constructed at Seton Hill. This building served as a mother house and academy until other new buildings were constructed. The school conferred high school diplomas to many, and by 1912, it became a two-year college. By 1918, a full four-year program was accredited by the state. (Courtesy of the Cy Hosmer Collection.)

The Westmoreland County Jail was erected in 1883 immediately behind the then courthouse. It functioned until 1968, when it was demolished; having only 72 cells, the jail had outlived its usefulness. The very visible clock tower was a landmark for those years. (Courtesy of Edward H. Hahn, Archives, Westmoreland County Historical Society.)

Housed at Mount Odin when it was formed in May 1905, Troop A, Pennsylvania State Police, was the first of four original troop locations and is the only survivor of those first four. In 1913, Troop A relocated to Point Lookout, its current location on the east side of town.

In 1912, the young Troop A, Pennsylvania State Police, poses for an official group photograph. Keeping the barracks at Mount Odin proved inconvenient, since the horses were stabled several miles away at what is now Lynch Field. Motorized transportation was a few years away.

Organized in 1905, the Southwest Greensburg Fire Department used the borough building at Brandon and Alexander Streets beginning in 1908. The first truck was purchased in 1918. In 1973, a spacious new facility was constructed at Alexander and Guthrie Streets. (Courtesy of the Cy Hosmer Collection.)

In formal dress uniforms, Hose Company No. 3's drum corps poses in front of the old No. 3 fire house in 1927. The drum corps was begun in 1906, with bugles added in 1925. Even today, Hose Company No. 3 has the largest number of members in the drum corps. (Courtesy of Edward H. Hahn, Archives, Westmoreland County Historical Society.)

During World War I, a detachment from the 3rd Pennsylvania Infantry was stationed at Radabaugh to guard not only the tunnel but also all trains entering it. The Pennsylvania Railroad was the single most vital supply line in the country, and every tunnel and bridge had troops. The United States was taking no chances. (Courtesy of the Cy Hosmer Collection.)

In 1910, the borough of Greensburg acquired the John A. Marchand home, on North Main Street at the current site of the Westmoreland Museum of American Art parking lot. After becoming a city in 1928, Greensburg continued to use this structure as its city hall until acquiring the West Penn Railway Terminal in 1954. This Marchand home was one of several on land immediately north of the railroad. (Courtesy of the LeRoy Smeltzer Collection.)

Although discussed for decades, it was not until 1925 that a suitable monument was erected to honor the Civil War veterans. By then it was named the Westmoreland County Soldiers and Sailors Monument to encompass all wars. The veterans paid for the monument themselves. Located at the borough building, it was moved a few feet in 1958 to its current spot at the Westmoreland Museum of American Art.

Ludwick Hose Company No. 1 was organized in 1896 to serve Ludwick Borough. When Ludwick was annexed into Greensburg in 1906, this building became Hose Company No. 6. It was located on the north side of West Otterman Street, near the railroad. This structure survived until 1969. (Courtesy of Edward H. Hahn, Archives, Westmoreland County Historical Society.)

The former Hose Company No. 3 (Bunker Hill Hose Company) fire hall is seen here at Christmas 1940, with its annual holiday lighting display. Built in 1894 on Grove Street, it was replaced in 1954 with a new facility facing Alexander Avenue. The home of the police chief, Walter N. Hutchinson, is seen next door. (Courtesy of the LeRoy Smeltzer Collection.)

This is a c.1925 photograph taken at Hose Company No. 3 (Bunker Hill Hose Company) on Grove Street. The small child is J. Edward Hutchinson, longtime chief of the Greensburg Volunteer Fire Department. Holding "Hutch" is his father, Walter, then chief of police. Hutch has been fire chief since 1953 and is one of the community's most outstanding citizens. Also pictured is former chief Oscar Myers (left front). (Courtesy of the LeRoy Smeltzer Collection.)

The Greensburg Country Club was founded in 1904 along the trolley line to Oakford Park. The barn was used to house groundskeeping equipment. The original clubhouse was destroyed by fire in 1906. There was another devastating fire in 1998. (Courtesy of Edward H. Hahn, Archives, Westmoreland County Historical Society.)

This old stone farmhouse is located below the clubhouse on the Greensburg Country Club property. It dates back to 1796, when it was built by the Abraham Frantz family, whose son Jacob married Elizabeth Otterman. The old home has been used as a caretaker's cottage, among other uses. (Courtesy of Edward H. Hahn, Archives, Westmoreland County Historical Society.)

A Stinson Reliant is shown here on the ground in front of the snack bar and hangar at the Pittsburgh-Greensburg Airport. The airport opened in September 1929 and remained active until 1954, when the land was sold to C. A. West to develop the West Point Plan of homes. (Courtesy of the LeRoy Smeltzer Collection.)

This high-altitude view of the Greensburg City Airport at Carbon shows downtown Greensburg at the top right. Opened in 1947, the airport boasted a 2,600-foot runway. Airmail pickups were handled by All American Airways, later known as Allegheny Airlines and today as US Airways. Changing commercial needs forced the airport's closure in 1950. (Courtesy of the LeRoy Smeltzer Collection.)

This is the dedication of Greensburg City Airport on September 28, 1947. Visible is a DC-3 belonging to Capital Airlines, which later merged into United Airlines. The airport occupied the ridge that is currently the site of Central Catholic High School and St. Paul's Church. (Courtesy of the LeRoy Smeltzer Collection.)

A Capital Airlines DC-3 piloted by Greensburg resident Frank Fox comes in for a smooth landing at Greensburg City Airport shortly after the airport's opening in 1947. Visible to the left center is the Carbon fire hall. (Courtesy of the LeRoy Smeltzer Collection.)

West Penn Interurban Station was built in 1927 to accommodate both passenger and freight traffic on the extensive trolley network throughout southwestern Pennsylvania. Built on land formerly the site of the James and Mary Woods family home, it became Greensburg City Hall in 1954 after the demise of trolley service.

This August 9, 1952, scene in front of what was then the post office shows a West Penn Railways trolley beginning its final run to Uniontown. Penn Transit buses took over the local trolley routes, and other buses tried to provide service to a wider area, but nothing again would match the ease and convenience of the streetcars. (Courtesy of Edward H. Hahn, Archives, Westmoreland County Historical Society.)

There were three interurban lines chartered in the Greensburg area, but only West Penn Railway prospered and survived. Seen here in 1913 along Tremont Avenue at a charming passenger stop is car No. 220, which ran from downtown south to Youngwood, eventually extending to Uniontown, Fayette County. Greensburg's electric railways operated between 1890 and 1952, eventually succumbing to the flexibility of buses and the automobile. (Courtesy of the Cy Hosmer Collection.)

August 3, 1935, brought serious flooding to the area, as captured in this photograph of East Pittsburgh Street near the point. Jack's Run (Creek) frequently overran its embankment to flood the spine of the city. It would be 30 more years and several more floods before a serious flood-control project would be built. (Courtesy of the Cy Hosmer Collection.)

Jack's Run flooded again in the summer of 1951. This photograph shows South Main Street under water near Tom's Bar at 634 South Main Street. The Memorial Art Company structure was demolished in 2001. This flood reportedly caused over $1 million in damages. (Courtesy of Edward H. Hahn, Archives, Westmoreland County Historical Society.)

On July 11, 1919, Greensburg belatedly celebrated the return home of servicemen from World War I. This clambake at Miller's Wood, now the site of Westmoreland Mall, was marred by a fierce storm with lightning. Earlier in the day, there was a parade and other entertainment. (Courtesy of the LeRoy Smeltzer Collection.)

On a warm August evening in 1918, a speeding, heavily loaded 15-ton delivery truck bound for the local A&P grocery stores failed to negotiate a curve near the intersection of Brushton (now College) Avenue and Liberty Street. The truck jumped the curb and flipped over, killing eight-year-old Stella Clemens on the sidewalk. This vehicle accident was the worst in local history to that time. (Courtesy of the LeRoy Smeltzer Collection.)

"Old Red," built in 1862 at the site of the Greensburg Academy, sits alongside the new high school, built in 1897. Farther north we can see the Eidemiller home, which was torn down in the late 1970s. Old Red was demolished in 1924 to make way for yet a newer high school, built in 1927. The cannons were dedicated in 1898. (Courtesy of Edward H. Hahn, Archives, Westmoreland County Historical Society.)

The Fourth Ward school was built next to the existing school building on a tract of land between West Third and West Fourth Streets. The older building was demolished for a parking area years ago, and in 1984, the newer building was sold by the school district. Today it is used as offices. (Courtesy of the LeRoy Smeltzer Collection.)

The Fifth Ward schools are shown here. Bunker Hill School, to the right, was built in 1889 and demolished in the 1930s. The new Spring Street School was built in the 1920s and demolished in 1969. Today, the entire tract is vacant, with only recreation facilities in place. (Courtesy of the LeRoy Smeltzer Collection.)

Barely visible here, peeking above the roof to the left, is the original high school, built in 1897. It was demolished in 1960. The new high school (1927) is today the Greensburg Salem Middle School. This photograph shows the old Park Street island separating the school property from the Marchand homes across the street.

Oakford Park was established in 1896 along the streetcar right-of-way. This is the entrance at the intersection of Greensburg-Jeannette Road (Route 130) and Oakford Park Road. Over the years, the park has seen many family reunions and differing kinds of special entertainment events, from vaudeville and swing bands to the Three Stooges.

A view from 1910 shows Oakford Park, which operated into the 1950s. The grand swimming pool continued operations until 1977. This photograph shows the bridge over Brush Creek several years after the flood of 1903, which did major damage. Many buildings now stand in disrepair since closing. Most would not know that the auto repair garage near the park entrance was once a busy trolley barn. (Courtesy of the Cy Hosmer Collection.)

This photograph shows a view of Congressman George F. Huff's beautiful home, which graced the 200 acres atop Cabin Hill from 1885 to 1953. In that year, the large home, by then owned by the R. H. Jamison family, was torn down to make way for West Penn Power's (now Allegheny Power's) sprawling headquarters. The Georgian home set atop the hill had several trails through the woods, some of which still survive today.

Sellcroft was the sprawling farm and summer home of the John S. Sell family for many years. Located along the Lincoln Highway, it encompassed the land that is now the Westmoreland County Municipal Authority offices, as well as that of the former Greengate Mall.

Construction of a city street in 1920 was quite different than what is the usual construction method today. As is evident, most of the work was done by hand. The equipment that was used was certainly crude in comparison to modern construction tools. Here we see the crew building a curb where Henry and Grove Streets meet. (Courtesy of the LeRoy Smeltzer Collection.)

In this photograph, we see Henry Street (later renamed Washington Street) being paved in 1920 near Anderson's Market. Brick paving was common because bricks were locally produced and abundant. The final layer was tar. Paving of city streets proceeded rapidly in the 1920s throughout Greensburg. (Courtesy of the LeRoy Smeltzer Collection.)

This aerial view shows the north side of town. From the Penn-Albert Hotel in the center, follow Ehalt Street down to College Avenue, and on the northeast corner we see a long-forgotten home. No trace of this home exists. This photograph reveals how Greensburg appeared in the 1940s and 1950s, before the extensive changes made in the last 30 years. (Courtesy of Edward H. Hahn, Archives, Westmoreland County Historical Society.)

This sky view shows Walworth at its high point. Route 119 is visible on the left, and the Southwest Branch of the Pennsylvania Railroad is on the right. Also note the Huff carbarn, located at the left next to Route 119. By the time of this photograph, Route 119 had already been enlarged to four lanes. (Courtesy of the Cy Hosmer Collection.)

In February 1916, the Greensburg Ice and Coal Company, located on Stokes Street at the Pennsylvania Railroad, was demolished. By then, refrigeration and central heating had made the sale of ice to homes in the summer, and coal in the winter, less profitable. Other ice plants remained into the 1970s, but the large facilities were all gone. (Courtesy of Edward H. Hahn, Archives, Westmoreland County Historical Society.)

Since early in the century, Daniels & Miller operated this growing scrap-iron and steel yard next to the railroad on North Hamilton Street, right beside the Westmoreland Produce Company. Late in the second decade of the 20th century, Daniels & Miller, outgrowing its existing space, acquired the Westmoreland Produce Company warehouse. It thrives today in the same location. (Courtesy of Edward H. Hahn, Archives, Westmoreland County Historical Society.)

At the Fifth Ward ball field facing Stone Street, Hose Company No. 3 digs in against an unlucky opponent. This team featured Ed Hutchinson and other well-known local citizens. The team was managed by the father of Penn State football voice Fran Fisher. (Courtesy of the LeRoy Smeltzer Collection.)

The Mountain View pool, built in 1925, was a gathering spot for young people all summer long. It also attracted serious swimmers, including diver Richard Kessler, seen here in 1940. Two years later, young Richard would need his diving skills and more as he served on a destroyer for the U.S. Navy in the Pacific theater. The pool lasted several decades but succumbed to old age in the 1970s. (Courtesy of the LeRoy Smeltzer Collection.)

77

Lynch Field was a racing track and home to the county fair each year until 1900. By 1911, Westmoreland Polo and Hunt Club took over the track to play polo. Thomas Lynch bought the property much later and donated it to the city for recreational purposes. The city fathers in turn named the tract after Lynch. (Courtesy of Edward H. Hahn, Archives, Westmoreland County Historical Society.)

The Coliseum was built in 1906 at Vannear Avenue and West Third Street. For over 40 years, this facility served as a roller rink, dance hall, exposition hall, sports arena, and banquet hall. A new automobile show is seen here. The vast building was destroyed in a fire on December 7, 1949. (Courtesy of the LeRoy Smeltzer Collection.)

Here we see a photograph of the action at Offutt Field in the fall of 1930, as Greensburg High School played Connellsville. Notice the white-shirted officials. Looming large in the background is the Greensburg Lumber & Mill Company, at its original location on East Pittsburgh Street. Founded in 1888 as the J. Covode Reed Planing Mill, it was acquired by the Millen family in 1918. After a disastrous fire in 1940, the business moved to South Urania Avenue, until closing in the 1980s. Offutt Field, formerly Athletic Park, was renamed in 1928 for James Offutt, a noted civic leader and school board member, who was also the son of well-known physician Lemuel Offutt. (Courtesy of the LeRoy Smeltzer Collection.)

Elephants signal the arrival of the circus for its annual performance at either Hilltop or South Greensburg. Here we see the Cole Brothers Circus train unloading at Huff Avenue, adjacent to the former Walworth Company (Kelly & Jones), for the parade to the circus grounds, an event watched by hundreds of enthusiastic children and adults. (Courtesy of LeRoy Smeltzer Collection.)

The Fifth Ward ball field had uses other than just baseball. Seen here is Hose Company No. 3's carnival, which they sponsored annually, beginning in the early 1920s. The Ferris wheel is sitting on Grove Street, just west of Anderson's Market. Notice the lack of home sites at the top of the photograph. Today this view is filled with homes and divided by the Greensburg bypass. (Courtesy of the LeRoy Smeltzer Collection.)

Below the railroad tracks and near the old quarry on Wilson Avenue was a public ice-skating rink that flourished in the 1930s and 1940s. Cold winter days saw large crowds honing their skills on the rink. (Courtesy of Ned Booher.)

This snowy scene is at Cowan's Cabin, Mount Odin, in 1940. Ludwick firefighters demolished the log house owned by the Williams family, and built this cabin c. 1905. Since Dr. Cowan willed his sprawling estate to the city, Greensburg has operated Mount Odin Park, golf course, and tennis courts and has provided picnic facilities, including the cabin. (Courtesy of the LeRoy Smeltzer Collection.)

These lovely ladies were in attendance at the 1920 Swedish church picnic, held annually at Miller's Woods, east of town. The Swedish Lutheran Church is located at Brandon and Chestnut Streets in Southwest Greensburg. Today, it is known as Holy Trinity Lutheran Church. (Courtesy of the LeRoy Smeltzer Collection.)

April 30, 1916, was a beautiful spring day for a Sunday drive on the Lincoln Highway just outside of Greensburg. Apparently, it was also a beautiful day for a stroll. How nice everyone looked! (Courtesy of the LeRoy Smeltzer Collection.)

Here we see an early-20th-century parade driving south on Pennsylvania Avenue, with a string of open-air autos filled with people. Glaringly absent in the parade are any horses. This photograph shows the intersection of South Pennsylvania Avenue and West Pittsburgh Street. On the left is the Keystone Hotel, and on the right are the county jail and the Cope Building. (Courtesy of the Cy Hosmer Collection.)

In what appears to be the same parade as in the previous photograph, here we see Jamison family members bringing out their automobiles, all polished for the occasion. The locals in the cars are dressed in their Sunday finest. There were a number of these parades, apparently for the purpose of showing off the newfangled automobile. (Courtesy of David Jamison.)

The original Fourth Ward school building is visible in this September 1916 photograph of one of the many floats appearing in the Civic and Industrial Parade. Note the stone wall along Euclid Avenue, as well as the rear of the First Christian Church, fronting on South Pennsylvania Avenue. The old school is now a parking lot. (Courtesy of Edward H. Hahn, Archives, Westmoreland County Historical Society.)

This view of a float from the 1916 parade shows the unusual home at the corner of West Fourth Street and Euclid Avenue. This home was demolished to make way for the new Fourth Ward school immediately adjacent to the original Fourth Ward school. The new school survives today as Fourth Street Square. (Courtesy of Edward H. Hahn, Archives, Westmoreland County Historical Society.)

A parade in 1912 affords a look at South Main Street from Second Street, looking north. The Hotel Zimmerman stands to the far left. Also visible are Troutman's (on the northwest corner), the Masonic Building, and the Fisher House. (Courtesy of the Cy Hosmer Collection.)

As part of the July 11, 1919, veterans festivities, this parade featured veterans of all wars, floats, bands, dignitaries, and, seen here, the fairly new Troop A Pennsylvania State Police Mounted Unit, approaching the intersection of South Pennsylvania Avenue and West Fourth Street. Some Civil War veterans can be seen in the cars immediately behind the troopers. (Courtesy of the LeRoy Smeltzer Collection.)

This view of the festivities, taken near East Pittsburgh and St. Clair Streets, shows a hospital float, with nurses riding in a new Chevrolet truck. The parade route would continue on East Pittsburgh Street, up the hill, and out to Miller's Woods for a clambake. (Courtesy of the LeRoy Smeltzer Collection.)

This 1940 photograph shows the high school band marching on Main Street. Isaly's, Ohringer Home Furniture Company, Kroger, and the Barclay Bank are seen behind the band. (Courtesy of the LeRoy Smeltzer Collection.)

Halloween costumes have changed considerably since 1936. These few youngsters are scaring the Spring Street residents during trick or treat. (Courtesy of the LeRoy Smeltzer Collection.)

This photograph shows a parade containing a float sponsored by the J. R. Klingensmith Company, which was located on North Maple Avenue, near East Pittsburgh Street. Visible is the Atkinson YMCA, built in 1911 with money from the D. S. Atkinson estate. The YMCA continues its important work today in the same building, which has been remodeled and expanded. (Courtesy of Edward H. Hahn, Archives, Westmoreland County Historical Society.)

As they had previously in 1898 and 1917, Greensburgers gathered at the train station in March 1942 to bid farewell to the young men inducted into or volunteering for military service. Here, we see that the station and surrounding area are packed solid with well-wishers watching as several troop trains, heading to all parts of the United States, pull into and out of the Pennsylvania Railroad station. (Courtesy of the LeRoy Smeltzer Collection.)

On March 26, 1942, after three months of bureaucratic wrangling, a send-off was finally staged for the young men inducted into the service of their country. World War II draftees marched from Main Street to the train station. Some are seen here on Harrison Avenue in front of the Chrome Room at the Penn-Albert. (Courtesy of the LeRoy Smeltzer Collection.)

Farther back in the march are other young men, seen here on West Otterman Street in front of the Stark Block. Many thousands of Greensburgers were out along the route to wish them well. (Courtesy of the LeRoy Smeltzer Collection.)

As the crowd leaves the station, having said their emotional farewells to the young draftees and recruits in March 1942, there must have been the somber realization that some of these brave young men would not return. Sadly, time would confirm the large number of local citizens killed in World War II. (Courtesy of the LeRoy Smeltzer Collection.)

This attractive farm is the Silvis farm, located off Route 136. The Silvis Dairy Store, operated by the same family at 10 East Second Street, was a popular eating spot in town until the 1960s, when the city acquired the property for a parking lot. (Courtesy of Edward H. Hahn, Archives, Westmoreland County Historical Society.)

From 1790 on, an inn stood at Main and West Pittsburgh Streets, known first as the Drum House, then as Black's Hotel, and later as the Fisher House (pictured here). This building was a popular meeting place well into the 20th century. During the 1794 Whiskey Rebellion, the U.S. Commissioners were housed here. As the establishment was strategically situated across from the courthouse, the bench and bar could often be found here. (Courtesy of Edward H. Hahn, Archives, Westmoreland County Historical Society.)

When the Baughman Building was demolished, the Barclay Westmoreland Trust Company built this attractive new banking facility at Main and East Pittsburgh Streets in 1928. Barclay would merge into Mellon Bank in 1958 and would later be acquired by Citizens Bank. Despite the changes in ownership, it remains the Barclay Branch. (Courtesy of the Cy Hosmer Collection.)

The Westmoreland Grocery Company was located on West Otterman Street between North Washington and Depot Streets. Here we see both the men and the delivery truck decked out for a parade. Several grocery warehouses were located at this early commercial hub. Charley Brothers would acquire this site years later. (Courtesy of Edward H. Hahn, Archives, Westmoreland County Historical Society.)

Founded in 1906 by brothers William and Anton Anderson, Anderson's Market has remained to the present day a full-service, family-run grocery store in the Fifth Ward. William's son, Oscar "Bud" Anderson, carried on until selling to William Holtzer in May 1989. This view shows the store's first location, across the alley from its present site at 612 Grove Street. (Courtesy of the LeRoy Smeltzer Collection.)

In this 1930 photograph taken in front of the new Anderson's Market, we see the short-lived Anderson's Market baseball team. Oscar "Bud" Anderson is on the far right in the third row. During the 1880–1940 years, Greensburg had many local teams and a minor-league franchise. Major-league teams on tour, among them the Boston Red Sox and the St. Louis Cardinals, played games here with the local teams. (Courtesy of the LeRoy Smeltzer Collection.)

The Mohler Motor Company operated a car dealership at the eastern convergence of Pittsburgh and Otterman Streets beginning c. 1925. E. W. Mohler got into the business in 1909. His son, William G., and his grandson, William M., continued the family business selling Ford, Mercury, and Buick products. In addition to this location, the Mohlers operated across Pittsburgh Street to the south, eventually moving east on the Lincoln Highway. Grandson Bill Mohler owns Sendell Motors a little farther east of town today. (Courtesy of Bill Mohler.)

A short distance east of Mountain View Inn, on the south side of the Lincoln Highway, A. J. Thomas built his Buvett Inn. It offered gasoline, dining, and overnight cabin accommodations to travelers. It sold at least Texaco, Gulf, and Sunoco gasoline at the same time. Nothing remains of the Buvett today. (Courtesy of Ned Booher.)

On the Greensburg side of Mountain View Inn, the hilltop crossed by the Lincoln Highway was called Huckleberry Hill. Here on the Joseph Shearer farm was established Huckleberry Inn. It offered gasoline and a food stand selling sandwiches, hot dogs, soda, ice cream, and a snack known as a "slobber bobber." The original building has been converted into a private home in use today. (Courtesy of Ned Booher.)

Westmoreland Hospital relocated to its present site in 1898. By the 1930s, as pictured here, a number of buildings had been added to the campus, including a nurses' home, out of sight on the right. The hospital would continue to evolve over the years, and today it is very difficult to see any trace of the buildings shown here. (Courtesy of the Cy Hosmer Collection.)

Henry G. Sample operated Greensburg Electrical Supply Company at 108 East Otterman Street, in the Bank and Trust Building, into the 1920s. Today Mr. Toad's Restaurant occupies this location. (Courtesy of Edward H. Hahn, Archives, Westmoreland County Historical Society.)

At Southwest Junction, where the main line of the Pennsylvania Railroad meets the Southwest Branch, there was an intricate, electropneumatic interlocking system, controlled by Southwest Tower. No longer functioning, the junction funneled traffic in and out of the branch line. Visible in the center is the tunnel exit, which permitted westbound trains to cross under the main line onto the southbound Southwest Branch line. (Courtesy of the Cy Hosmer Collection.)

The beautiful Pennsylvania Railroad station is seen here in the late 1930s from the Penn-Albert Hotel. The passenger platforms were much larger than today's shelters. In its heyday, this station was the fourth busiest on the main line. It is still an active stop for Amtrak, with four trains daily. (Courtesy of the LeRoy Smeltzer Collection.)

Passing through Greensburg on May 29, 1922, was the largest train of locomotives ever moved across the country. Philadelphia's Baldwin Locomotive Works built the 50 steam engines for the Southern Pacific Railroad. Termed the Prosperity Special, it was greeted here, as in every main-line town, by hundreds of onlookers on its journey westward. (Courtesy of the LeRoy Smeltzer Collection.)

This is a view of downtown Greensburg from Ludwick, along the main line of the Pennsylvania Railroad, looking east. The area to the left front is the Seton Hill University campus. The area to the right front shows the old freight yard between Stokes and Depot Streets. Due east is the Penn-Albert Hotel, which dates this scene after 1921. (Courtesy of the LeRoy Smeltzer Collection.)

The center home in this photograph was occupied during and after the Civil War by Stephen Collins Foster's wife, Jane, and his daughter, Marion. The home on Grove Street survived well into the 20th century but was finally demolished for part of the Anderson's Market parking lot. (Courtesy of the LeRoy Smeltzer Collection.)

At the intersection of Huff Avenue and Route 119, at the present site of a fast-food restaurant and car wash, sat the Huff carbarn. Originally built for the Pittsburgh, McKeesport & Greensburg Railway, it was later acquired by West Penn Railways. Here the maintenance and repair work was done to the fleet. (Courtesy of Edward H. Hahn, Archives, Westmoreland County Historical Society.)

This 1900 scene of Main Street in the snow depicts the old courthouse gracing the corner, and the Fisher House, across Pittsburgh Street. In the distance is the spire of the First Lutheran Church. The lack of snow on the trolley tracks indicates that the streetcars were running, despite the weather. (Courtesy of the Booher Family Archives.)

This 1940 image of Seton Hill's entrance shows the pergola that graced the corner for a time. Once Route 130 was paved along the streetcar right-of-way, the area known as Mudville faded from memory. As attractive homes were built along the route, and with the lovely campus shielding the western side, this route became the most attractive entrance to Greensburg. (Courtesy of the Booher Family Archives.)

This view, taken at the same time as the previous photograph but from the opposite direction, displays part of the First Ward. Bell Telephone has not yet constructed its facility on the corner, but the armory can be seen, as can Holy Sacrament Church and the larger structures in the central business district. (Courtesy of the Booher Family Archives.)

Three
Fading Glory

As Greensburg journeyed through the 1940s and 1950s, at the peak of the economic boom after the war, the excitement and growth of that boom were actually sowing the seeds of the decline coming in another decade. The common threads that bind a community together through institutions and traditions need constant vigilance. As in many small cities with poor or nonexistent planning, the 1960s brought change that would forever make over the landscape.

Buildings, businesses, and industry disappeared or dramatically changed during this period. There was a push to move into the townships, leaving behind and unoccupied many worthy structures. No one seemed ready to meet the challenges of an economy that was growing but growing elsewhere. It took 20 years of decline before new technologies were embraced and implemented, reflecting a changed economic base and a newly rediscovered optimism about the future.

The sons and daughters of the families who had contributed to the tremendous growth of this community earlier in the century would respond to the different needs, provide new skills, and demonstrate the needed resolve to see Greensburg through the most difficult period in its history.

Founded in 1886, the Westmoreland County Children's Aid Society acquired the Frank Scherer mansion in 1897 by trading its current building for this one at 514 West Pittsburgh Street. Societal changes doomed the orphanage, but several thousand children were cared for during the society's existence. The building was demolished in 1972. There is a commemorative marker where the home stood, in what is now a hospital parking lot. (Courtesy of the Cy Hosmer Collection.)

The Robert G. Kotouch Post No. 318 of the American Legion dates to 1919. The post purchased the Leonard Keck home, formerly the George Huff home, in 1923. Named after the first soldier from Greensburg to die in World War I, the post was one of the most active organizations in the county. The former post home is hardly recognizable today, after extensive renovations into professional offices. (Courtesy of Edward H. Hahn, Archives, Westmoreland County Historical Society.)

Thomas Drug was founded by Harry F. Thomas, who built this structure bearing his name. The Casino Theater, next door at 8 North Pennsylvania Avenue, was built in 1907 as a movie house. Later, the Casino closed and became Harvey's Restaurant for several decades. Thomas Drug closed in 1996, and another business now occupies the building. (Courtesy of Edward H. Hahn, Archives, Westmoreland County Historical Society.)

Adjacent to the courthouse was the Maddas Bank and Trust Company, started in 1905. Eventually demolished as part of the Courthouse Square development, it served as a courthouse annex in its twilight years. Almost unseen here is the Busy Bee Lunch, squeezed in closely between its massive neighbors. (Courtesy of Edward H. Hahn, Archives, Westmoreland County Historical Society.)

This aerial view of Academy Hill c. 1954 shows Greensburg High School, constructed in 1927, now the middle school. Still standing is the old high school, built in 1896, immediately north of the middle school. In the lower right corner, at Main and Park Streets (now Academy Hill Place), are the Marchand properties, demolished for the Westmoreland Museum of American Art in 1959. Old City Hall, demolished in 1955, is seen with the Civil War Monument beside it. The monument was dedicated on May 30, 1925, by the Veterans of the Grand Army of the Republic. Also visible are Blessed Sacrament Cathedral and Temple Emanu-El. At the top of the photograph is an emerging Northmont development, as well as the Lloyd Huff home in Huff Park. (Courtesy of Edward H. Hahn, Archives, Westmoreland County Historical Society.)

This view from the railroad main line, looking toward the south, shows the Southwest Branch line at the upper left. At the top right center is the old German cemetery, later a city recreation area. At the bottom center is the Penn-Albert Hotel. In the center can be seen most of the notable buildings, past and present, on this side of town. (Courtesy of Edward H. Hahn, Archives, Westmoreland County Historical Society.)

St. Clair Cemetery was founded in 1856, originally at what is now St. Clair Park. After burial was forbidden within the city, several farms were purchased east of town, including the McCausland farm, to become the new cemetery site. Many of the great names in Greensburg history are interred at this peaceful setting. (Courtesy of Edward H. Hahn, Archives, Westmoreland County Historical Society.)

Joseph Thomas founded both his floral stores and the greenhouses shown here c. 1900. Located along the Jeannette Road, the greenhouses numbered two dozen at one time. His family continued to operate the greenhouses until the Greensburg Toll Road was constructed in the 1990s. (Courtesy of the Cy Hosmer Collection.)

For many years, the city held a Halloween parade. Seen here is the 1949 parade, in which the participants are walking north on Main Street, past Rand's Drugs, at the corner of West Pittsburgh and South Main Streets. (Courtesy of the LeRoy Smeltzer Collection.)

The crowd around the railroad station on September 22, 1917, indicates this is a send-off for troops going to war. Above the crowd on North Pennsylvania Avenue, we can see H. S. Coshey & Sons Funeral Directors and Livery. Built in 1905, this massive structure was demolished in 2004. It had been vacant and deteriorating for several years. (Courtesy of Edward H. Hahn, Archives, Westmoreland County Historical Society.)

Southwest Tower stood at the junction of the Pennsylvania Railroad main line and the Southwest Branch, which originated in Greensburg and ran south to Scottdale in 1871 and eventually to Fairchance, Fayette County. Until the modern era, Southwest Tower was essential for handling tonnage originating in the lucrative coal and coke areas surrounding the Greensburg-Uniontown corridor. Controlling ingress and egress to the main line from the south, it directed some of the heaviest tonnage on the entire railroad. (Courtesy of the Cy Hosmer Collection.)

This aerial view of Mountain View Hotel, today Mountain View Inn, shows the expansion of the original structure by the Booher family. Modern Route 30 is on the right, while the original Lincoln Highway is to the left. The fondly remembered swimming pool is still present in this 1950s photograph.

In 1958, the city began to raise money for a swimming pool at Lynch Field. With a huge helping hand from Thomas Lynch, who pledged $100,000, the effort successfully raised $250,000. Named the Veterans Memorial Swimming Pool, the facility opened in June 1962. (Courtesy of Edward H. Hahn, Archives, Westmoreland County Historical Society.)

As is still the custom before each football game, here we see Greensburg High School students parading down Main Street from the Academy Hill structure to Offutt Field. Taken in the fall of 1950, this photograph shows the Marchand homes at the top of the hill. The house on the extreme right was city hall. (Courtesy of Edward H. Hahn, Archives, Westmoreland County Historical Society.)

Here we see the Greensburg High students, cheerleaders, and band members parading back up Main Street to Academy Hill after a victory. Visible in this photograph from 1950 are F. W. Woolworth, First National Bank (later Southwest Bank), Thom McCann Shoes, Greensburg Drug, Craig Shoes, and Murphy's five-and-dime store. (Courtesy of Edward H. Hahn, Archives, Westmoreland County Historical Society.)

During the short life of the Greensburg City Airport at Carbon, this Quonset hut was constructed next to the old barn. The hangar was located on the property now owned by Greensburg Concrete Block and was torn down in the early 1990s. The airport runway ran from this location out to near Danny's Dairy Bar, now Jioio's Restaurant. (Courtesy of the LeRoy Smeltzer Collection.)

The long awaited Greensburg bypass was begun in 1958 and dedicated October 30, 1959, by Gov. David L. Lawrence. This photograph shows construction near Stanton Street, with Greensburg Central High School in the distance on the former Carbon Airport property. (Courtesy of the LeRoy Smeltzer Collection.)

After World War II, with the cold war on everyone's mind, a number of observation posts were established around the area. These were manned regularly by persons trained to observe aircraft and to distinguish between the friendly and the dangerous. This site was atop Westmoreland Hospital. Other sites included the high hilltop at Mutual. (Courtesy of the LeRoy Smeltzer Collection.)

Seen here in front of Anderson's Market in 1950 is the Joseph A. Sass Food Products truck making a delivery. Throughout the first half of the 20th century, Greensburg was home to a number of food distributors, which regularly supplied the local markets. This was prior to the mega-distributors that are prevalent today. (Courtesy of the LeRoy Smeltzer Collection.)

The Cabin Hill estate of Congressman George Huff would become headquarters to the West Penn Power Company. Some of the surrounding land became private homes or apartment structures. By 1960, the Tribune-Review occupied the tract on the right of the photograph. A new road was needed for the many vehicles headed to Cabin Hill. Once paved, this old trail became Cabin Hill Drive. (Courtesy of Edward H. Hahn, Archives, Westmoreland County Historical Society.)

After the war, an annexation led to the development of the Northmont Plan. This 1946 photograph shows the early street layout begun by Sampson Brothers. The tree-lined street at the top is Harvey Avenue. (Courtesy of Edward H. Hahn, Archives, Westmoreland County Historical Society.)

This wooden home on West Otterman Street was the home of Frank Peifly. Peifly and Henry Freight & Delivery was a going concern early in the last century. Remarkably, the old home survived over 100 years, before being demolished. (Courtesy of Edward H. Hahn, Archives, Westmoreland County Historical Society.)

Now a vacant lot, the Fred Crater house at West Otterman and Stokes Streets was a more formal home than many near it, complete with mansard roof. It is seen here shortly before its demolition in 1955. (Courtesy of Edward H. Hahn, Archives, Westmoreland County Historical Society.)

On South Maple Avenue, next to the YMCA, the city parking authority built one of numerous lots it constructed in the late 1950s. The authority was created in 1957 to provide several hundred needed spaces by constructing lots or garages. South Maple is a surface lot still in use. (Courtesy of Edward H. Hahn, Archives, Westmoreland County Historical Society.)

The Keystone Hotel, a landmark located on the southwest corner of West Pittsburgh Street and South Pennsylvania Avenue on the original Lincoln Highway, was one of over a dozen hotels that once served Greensburg. Owned and operated by Mark and Louis Mace since 1928, it was torn down in 1960.

This house at South Main and East Third Streets was home to Hon. Jacob Turney. He was a powerful 19th-century figure in Greensburg, serving as a lawyer and then district attorney, state senator, and congressman. The house survived well into the 20th century but was torn down for the construction of the Bononi parking lot in the 1950s. (Courtesy of Edward H. Hahn, Archives, Westmoreland County Historical Society.)

The parking authority also acquired the former Maple Avenue Hotel on North Maple Avenue in 1957. Instead of a surface lot, a two-level parking deck was constructed. In 2002, a similar but entirely new deck replaced it. (Courtesy of Edward H. Hahn, Archives, Westmoreland County Historical Society.)

Prior to the construction of the Greensburg bypass, the Mount Odin Drive-In was located on the Lincoln Highway and what is now North Greengate Road. Drive-ins fell on hard times, as they occupied too much valuable land, and the Mount Odin land was sold to become a K-Mart and other businesses. Gabriel Brothers occupies the K-Mart spot today. (Courtesy of Edward H. Hahn, Archives, Westmoreland County Historical Society.)

Having talked about it for years and having needed it for decades, the Jacks Run Flood Control Project was finally dedicated in October 1960. Both Governor Lawrence and Congressman John Dent came back to Greensburg to speak at the ceremonies, which were broadcast on WHJB radio. (Courtesy of Edward H. Hahn, Archives, Westmoreland County Historical Society.)

This aerial view of ITE, the former Railway and Industrial Engineering Company, looks north to the Walworth Company. Railway and Industrial was founded in 1926, in South Greensburg, to produce electrical equipment. It grew into a major employer. After a series of corporate mergers and acquisitions, it came to be known as ABB Power Products. (Courtesy of the LeRoy Smeltzer Collection.)

Ferguson's was located just west of Mountain View Inn on the Lincoln Highway, prior to the new alignment traveled today. Another popular stop for motorists, it was operated by the Lancaster family for many years. The structure remains today as a private home. (Courtesy of the Cy Hosmer Collection.)

W. F. Ulshafers' Tourist Home is no longer in business, but the building it occupied is located on the Lincoln Highway, east of town, behind Peaches & Cream. Because the Lincoln Highway brought unprecedented numbers of travelers through the area, many of these types of gas, food, and lodging businesses thrived. Unfortunately, the two small dollhouses have not survived. (Courtesy of the Cy Hosmer Collection.)

For over 100 years, the John W. Pollins home has graced the corner of South Pennsylvania Avenue and West Fourth Street. John W. Pollins Sr. bought the home, which was built in 1881. It has been home to lawyers John W. Pollins Jr. and John W. Pollins III. The senior Pollins was an organizer of the Westmoreland Trust Company and founder of the department store bearing his name. John W. Pollins III today maintains his law office there, and John W. Pollins IV lives in the upstairs quarters. (Courtesy of the Pollins family.)

As the economy of the area changed, few of the large West Pittsburgh Street homes could survive as private homes. Almost without exception, they were transformed into business buildings such as funeral homes, doctors' offices, realty companies, and similar entities.

The Pennsylvania Armory building, on North Pennsylvania Avenue, has been a fixture in Greensburg for many years. During World War II, it served as the site where area draftees reported for duty. In the early years, it was home to famed National Guard Company I. The building now houses the YMCA annex.

After construction of a new post office across the street, the old postal building, dating from 1911, became the Greensburg Hempfield Library in 1969. The 1911 building had also housed some federal offices for the area. Next door can be seen the home and office of Dr. Carl Freeman Pierce and his sons.

Constructed in 1926, the South Greensburg Junior High School sits atop Sheridan Avenue in the borough. When the combining of the various school districts occurred, the junior high school joined a list of several schools that closed. It is used today to house the Noah's Ark Child Center. (Courtesy of the Cy Hosmer Collection.)

Pictured here in 1912, the Southwest Greensburg grade school stood at the corner of Alexander and Guthrie Streets. The building was demolished many years ago. The land was green space and a playground until 1973, when the Southwest Greensburg Volunteer Fire Department built its new and spacious facility on the grounds. (Courtesy of the Cy Hosmer Collection.)

Constructed in 1930 (as the population of Southwest Greensburg by then warranted additional classroom space), this old school was used for a number of years after the merger that produced the Greensburg Salem School District. The school was eventually demolished and replaced by the Hutchinson Elementary School, one of three elementary buildings still in use by the district. (Courtesy of the Cy Hosmer Collection.)

Here we see the Crown Fuel Company, rather majestic for a filling station, on West Pittsburgh Street. This terrific example of how good service stations could look architecturally is now the location of Moore Tire Service. This was not a corner property until 1968, when Bortz Alley was widened into the much wider Bell Way. (Courtesy of Edward H. Hahn, Archives, Westmoreland County Historical Society.)

To make way for a new post office, the United Presbyterian Church (built in 1907) was demolished in 1965. The church merged with Calvary Presbyterian Church to form a new congregation known as Maplewood Presbyterian Church. (Courtesy of Edward H. Hahn, Archives, Westmoreland County Historical Society.)

Before a new postal facility was built on South Pennsylvania Avenue, several structures were demolished, including all of the buildings shown, which were replaced by a parking lot, then a parking garage, and now another parking lot. Only the former L. W. Bott home, on the corner of West Second Street and South Pennsylvania Avenue, survives. (Courtesy of Edward H. Hahn, Archives, Westmoreland County Historical Society.)

This grand old building was torn down to make way for a Troutman's addition in 1957. Troutman's prospered for a time thereafter but closed its downtown store in 1985 after 88 years in Greensburg. (Courtesy of Edward H. Hahn, Archives, Westmoreland County Historical Society.)

Until 1960, the Tribune-Review was housed in this three-story building on North Main Street. Sometime after the newspaper's relocation to Cabin Hill Drive, the old structure was demolished, along with other neighboring structures, to make room for a large parking lot.

As shown in the daily newspaper in January 1961, Greensburg was chosen for the first push-button telephone service in the nation. Greensburg was the test market for this new technology—and it was quite the success. Seen also on North Main Street are the Citizens for Kennedy headquarters, as well as the buildings, now razed, between the courthouse and West Otterman Street. (Courtesy of Edward H. Hahn, Archives, Westmoreland County Historical Society.)

In the booming 1950s, without a hint of the economic hard times ahead, South Main Street was alive with stores catering to the population. A look at the names on the storefronts confirms the variety of goods offered to the shopper. Greengate Mall opened in 1965, and everything changed. (Courtesy of Edward H. Hahn, Archives, Westmoreland County Historical Society.)

In 1940, fathers and sons pose at the Fifth Ward playground for this photograph. Both LeRoy Smeltzer (second row, third from left), and his son, Glenn Smeltzer (first row, sixth from left), are seen. Glenn generously provided to this publication the many photographs taken by his father. The senior Smeltzer was the unofficial photographer for the Fifth Ward. (Courtesy of the LeRoy Smeltzer Collection.)